MW01254610

A Keepsake

BRANDYWINE VALLEY

Antelo Devereux Jr.

4880 Lower Valley Road • Atglen, PA 19310

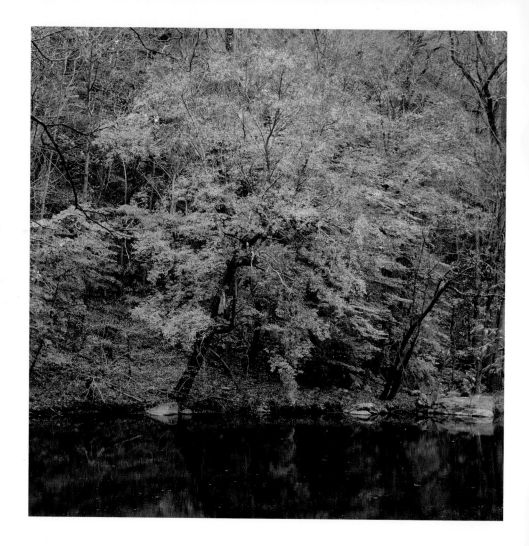

INTRODUCTION

The Brandywine Valley has become a brand name for a historic and picturesque region outside Philadelphia that approximately corresponds to the watershed of Brandywine Creek. The photographs roughly follow the creek from its headwaters in the Welsh Mountains of Chester County, Pennsylvania, to Chadds Ford, and the historic mill areas outside Wilmington, Delaware.

More than 300 years have passed since Chester County, along with Philadelphia and Bucks Counties, was organized by William Penn, whose father received a large land grant from English King Charles II in 1681. The grant included all lands north to south between the 40th and 43rd parallels and the Delaware and Susquehanna Rivers east to west. Indigenous Native American inhabitants—the Lenni-Lenape and Susquehanna cultures—were succeeded by colonial settlers: primarily English, Welsh, and German Protestants, Quakers, and Amish.

Philadelphia was the birth place of the United States, and Chester County, to the southwest, provided the natural resources that helped support the nation-to-be. The county's fertile land produced an abundance of food. Its streams, such as Brandywine Creek, provided energy for mills, while forgings from rudimentary iron mines and furnaces were used for war and peace. Agriculture remains a key part of the county's economy, which is now diverse and fully part of the twenty-first century. The digital age lives alongside the Amish.

Thanks to determined and successful efforts by the Brandywine Conservancy and similar organizations to save the area from development and maintain open space, a significant amount of land is under easement and remains undeveloped. Considering its close proximity to Philadelphia, Chester County and the Brandywine Valley form a very desirable place to live, work, and visit.

I hope the following images will give the viewer a sense of the beauty, history, and life of the Brandywine Valley and its environs. It has been a fun challenge capturing and editing them for this book. No doubt many wonderful places and buildings have been omitted, but such is the difficult process of editing.

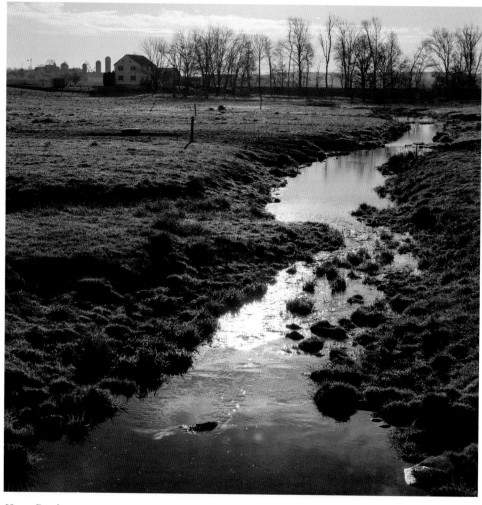

Honey Brook

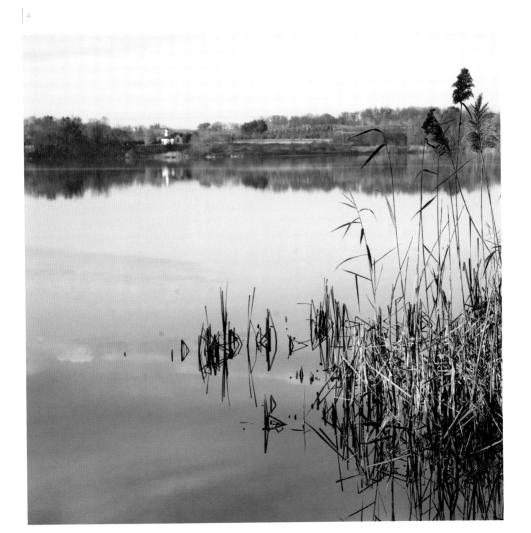

Honey Brook

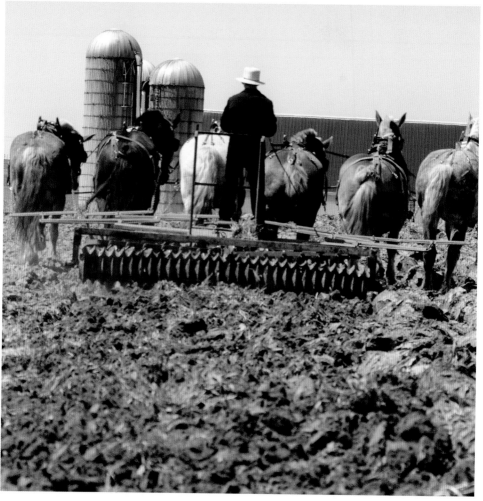

Honey Brook

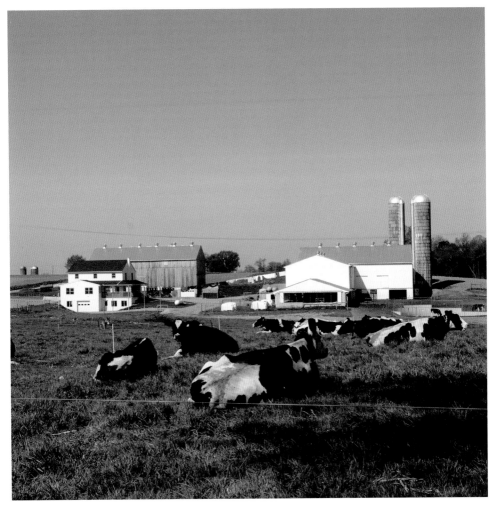

Honey Brook

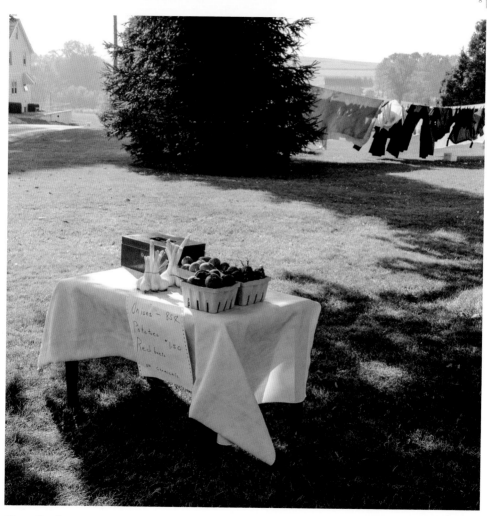

Honey Brook

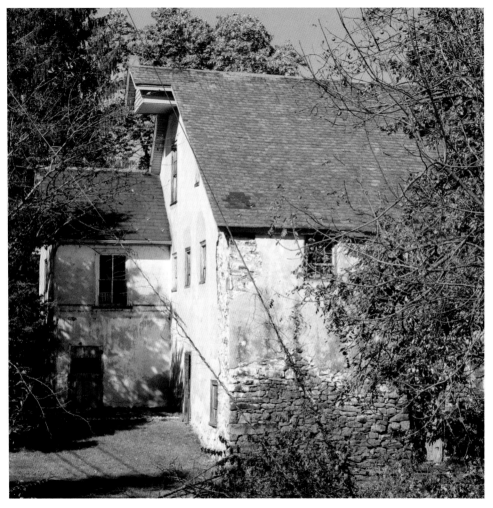

West Nantmeal

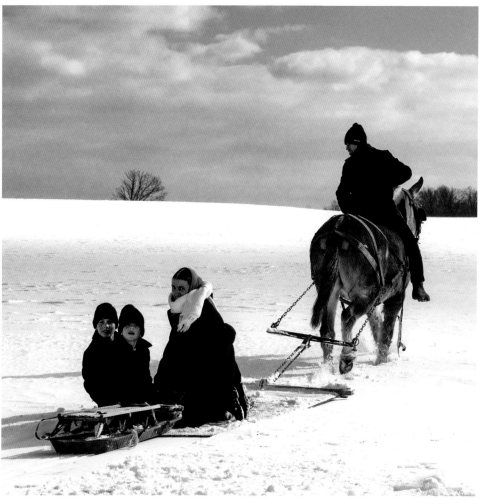

Fallowfield

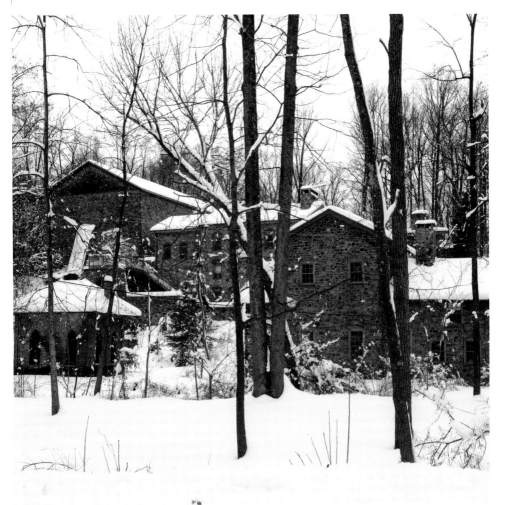

Isabella Forge (private), West Nantmeal

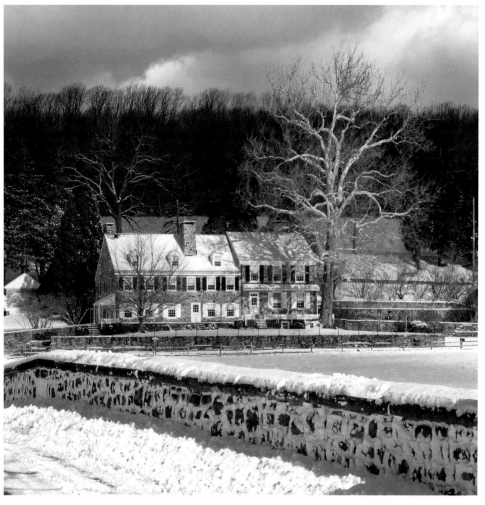

West Nantmeal

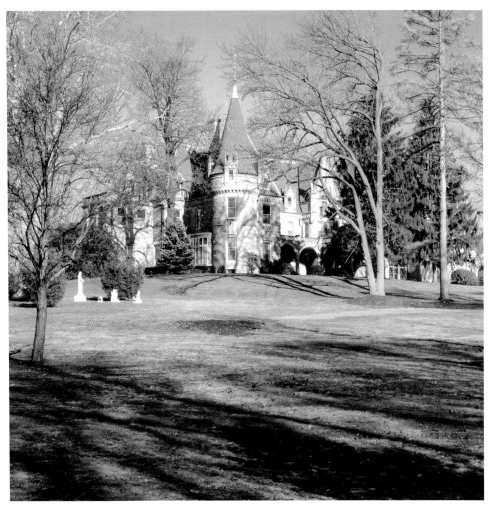

West Nantmeal

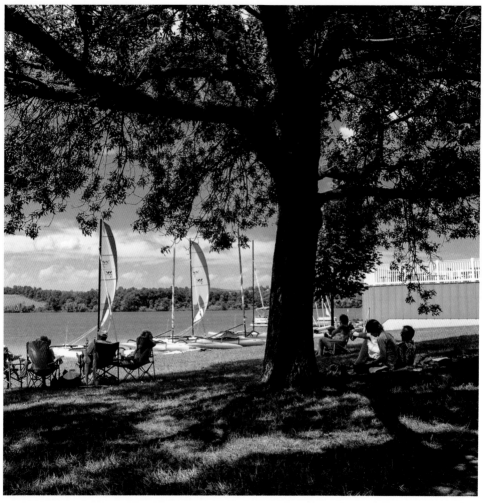

Marsh Creek State Park, Upper Uwchlan

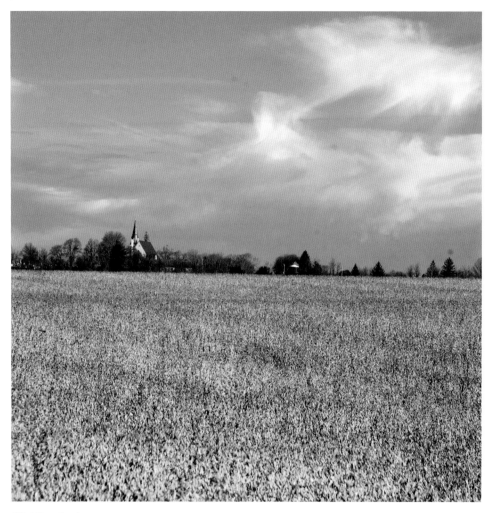

West Brandywine

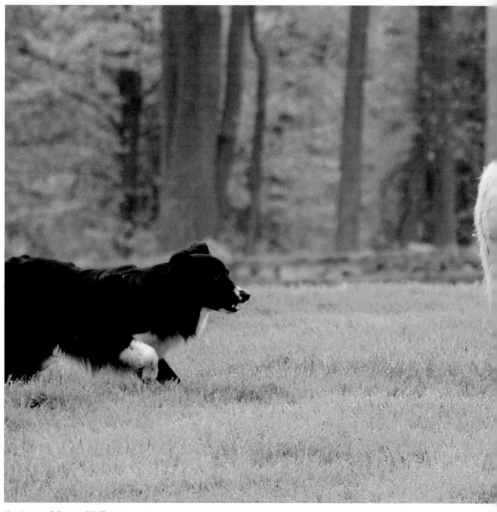

Springton Manor, Wallace

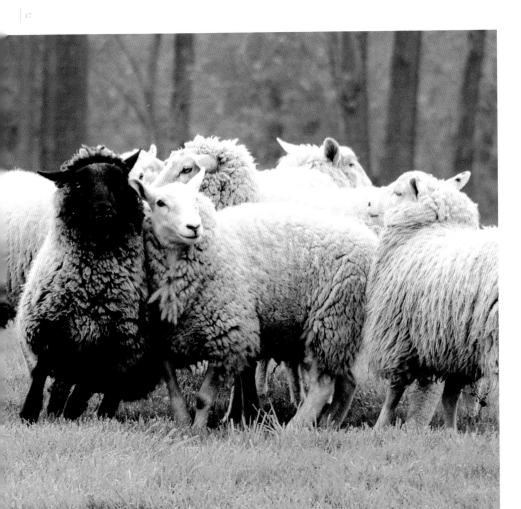

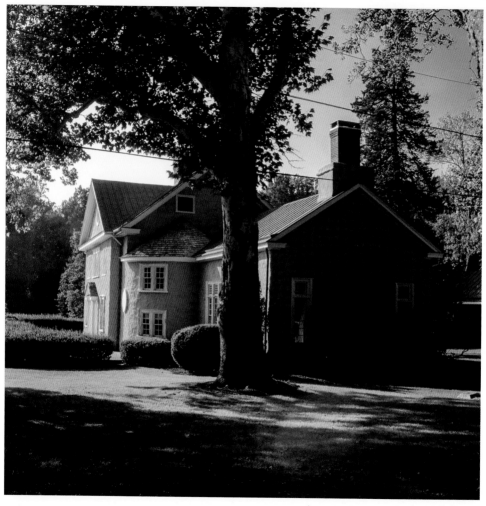

Hibernia Mansion, West Caln

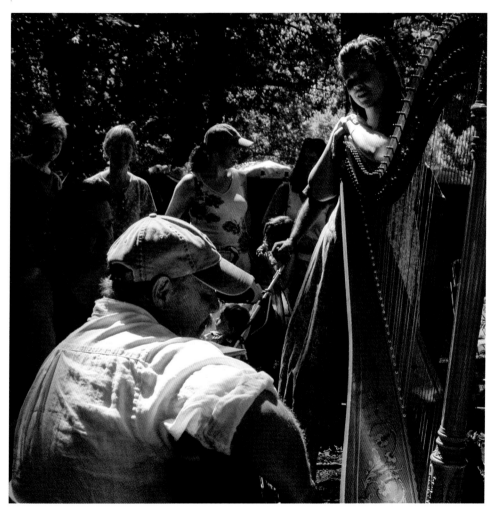

Old Fiddlers' Picnic, Hibernia County Park

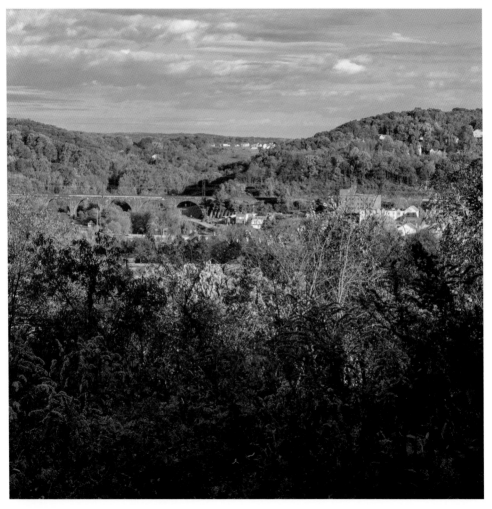

Coatesville

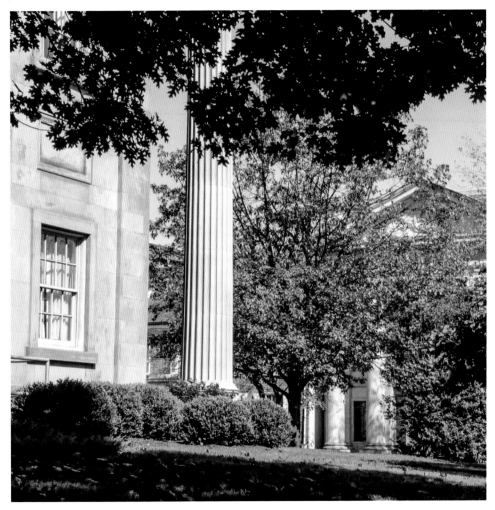

West Chester

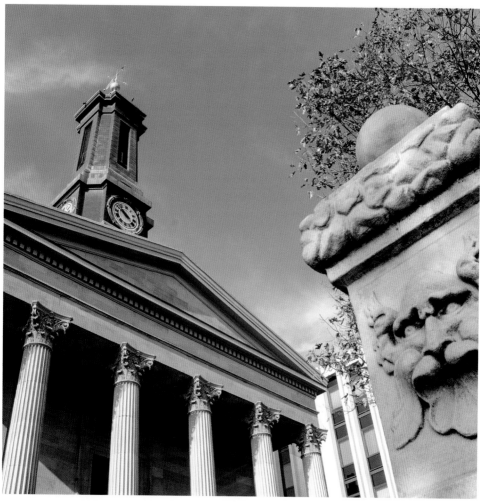

West Chester

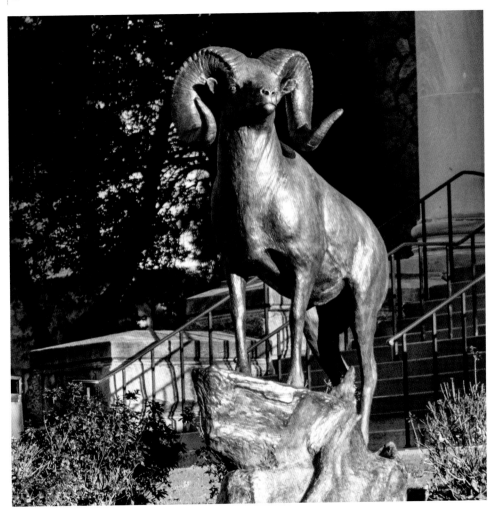

West Chester University, West Chester

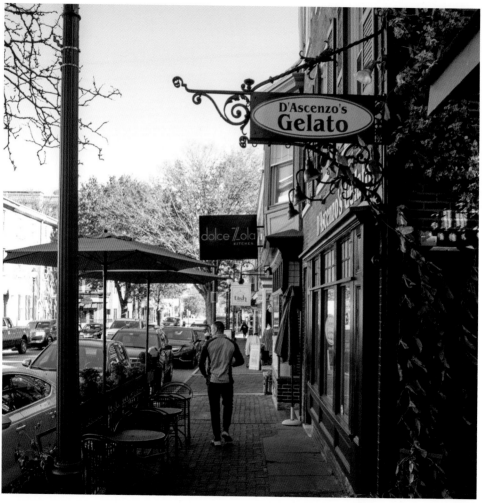

West Chester

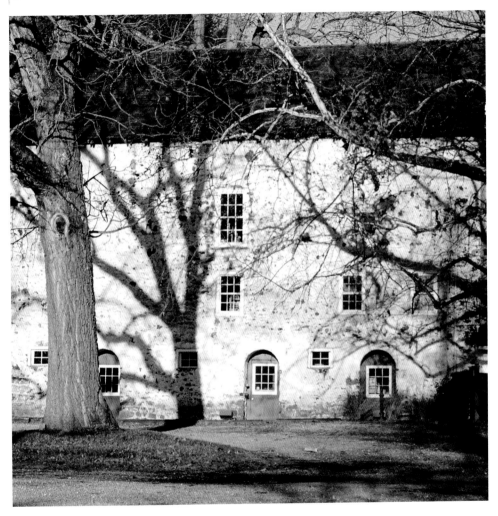

East Bradford

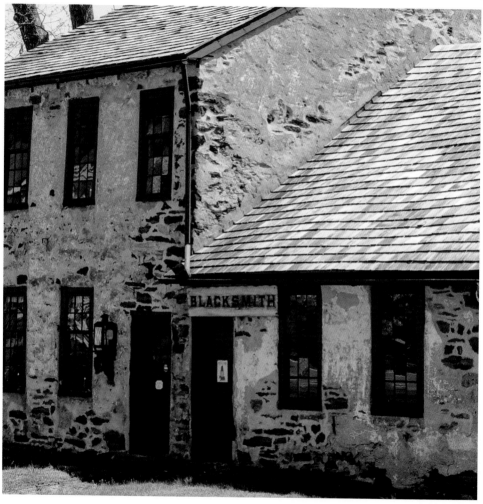

Marshallton

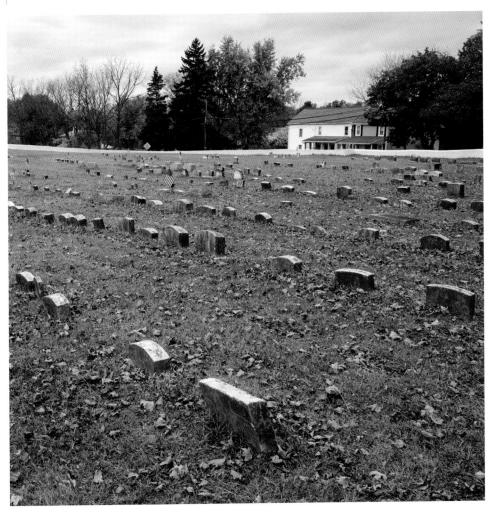

Ercildoun

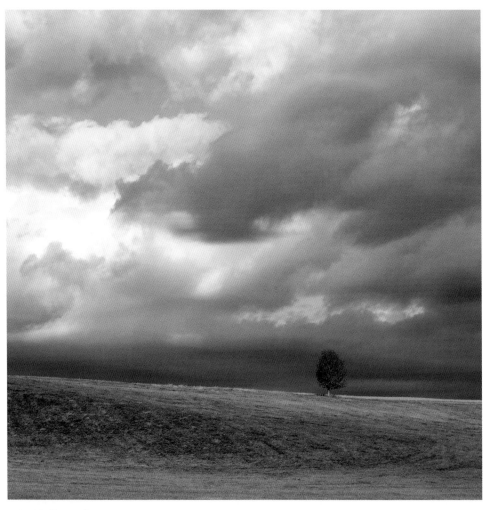

West Marlborough

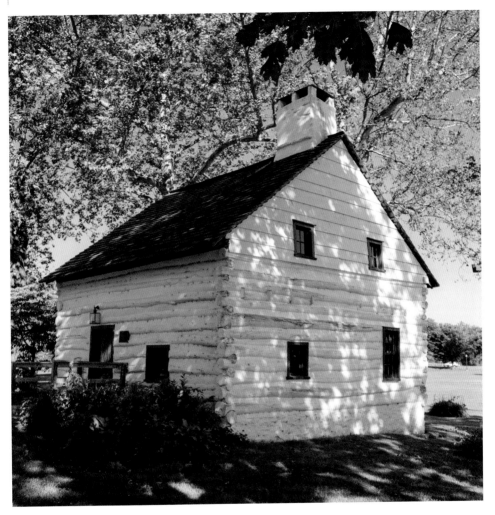

Downingtown

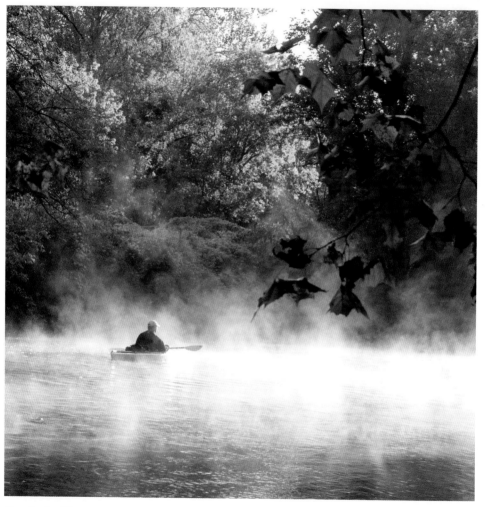

Brandywine River

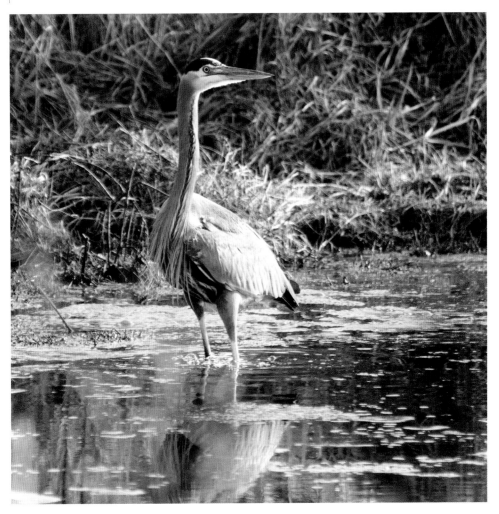

Great Blue Heron

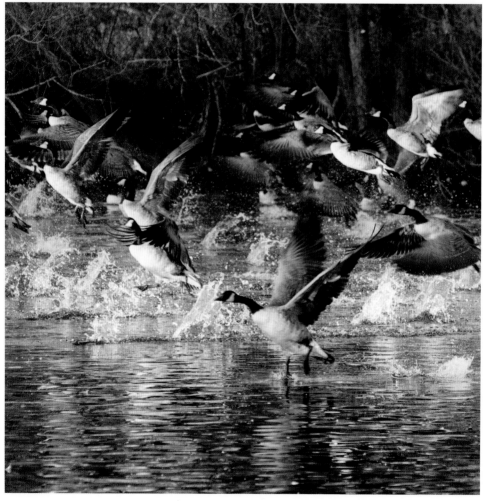

Canada Geese

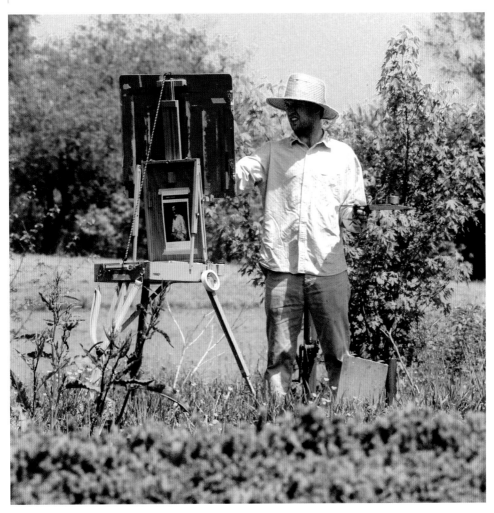

London Grove Township

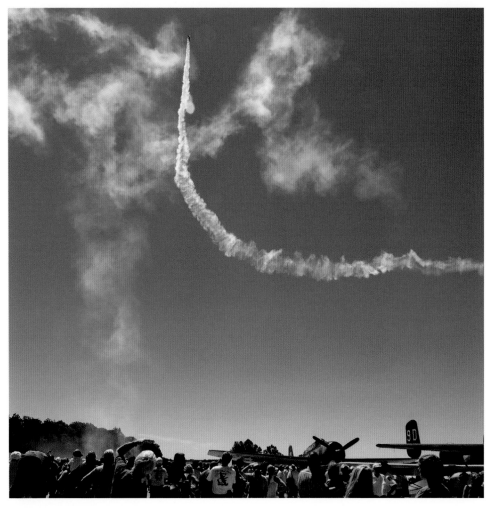

New Garden Airport

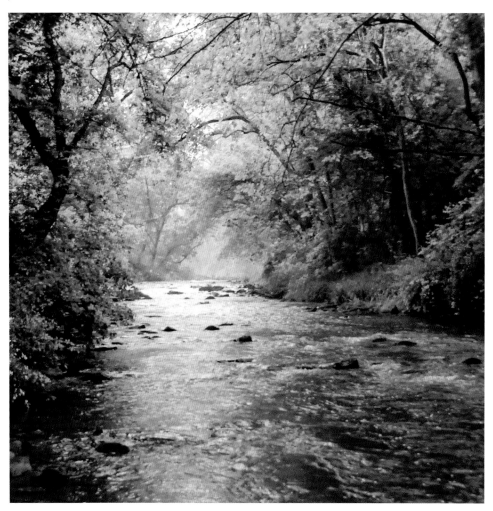

Brandywine Creek

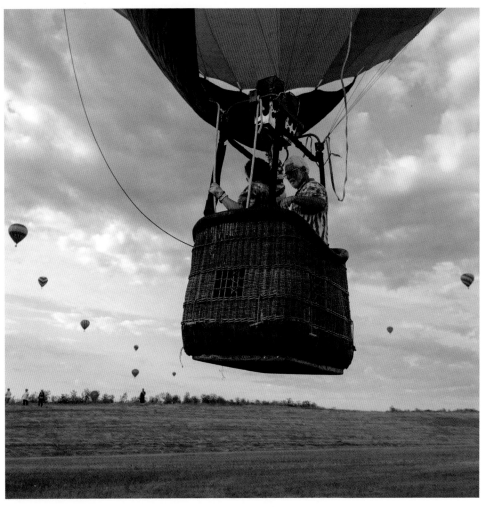

New Garden Airport

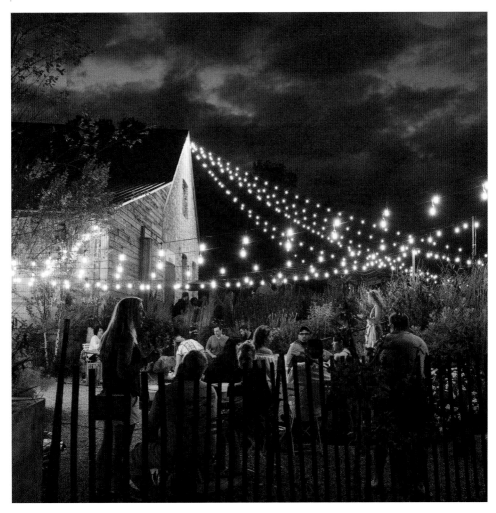

Creamery, Kennett Square

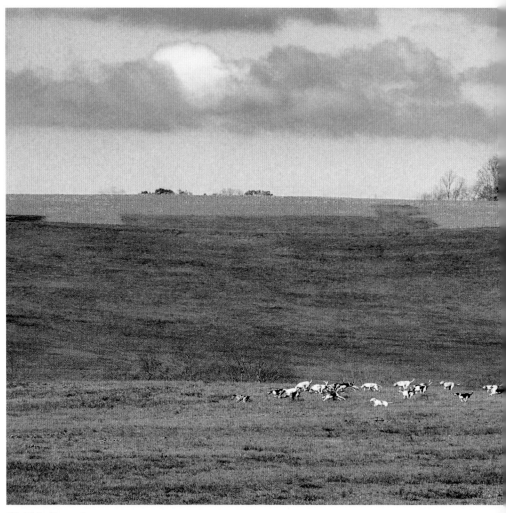

West Marlborough

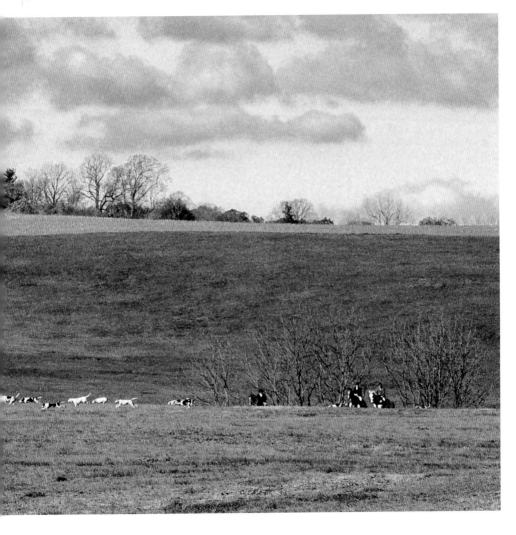

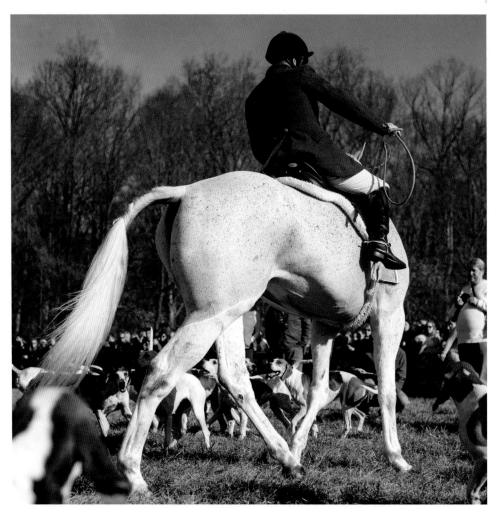

West Marlborough

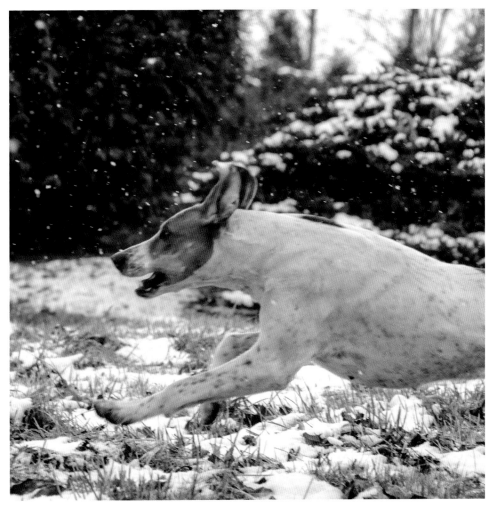

London Grove

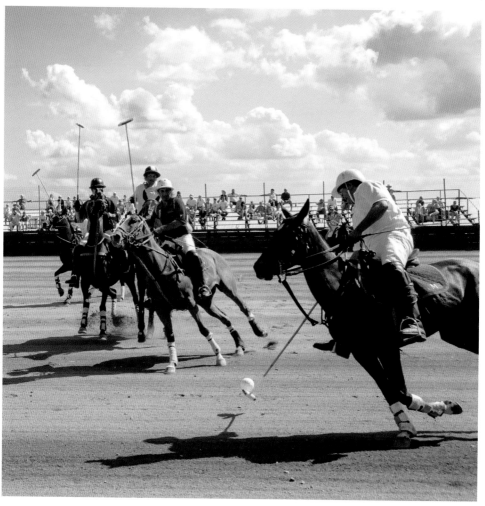

London Grove

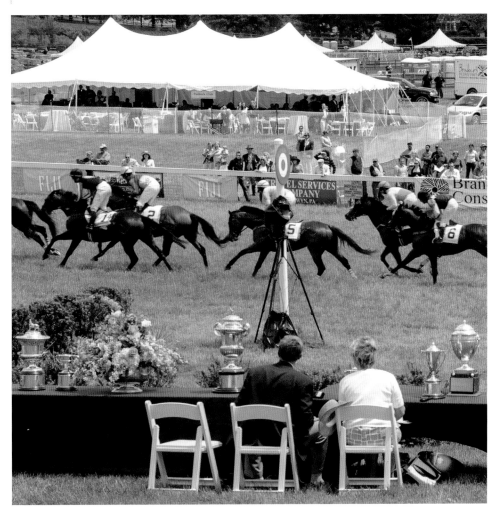

Radnor Races in support of the Brandywine Conservancy

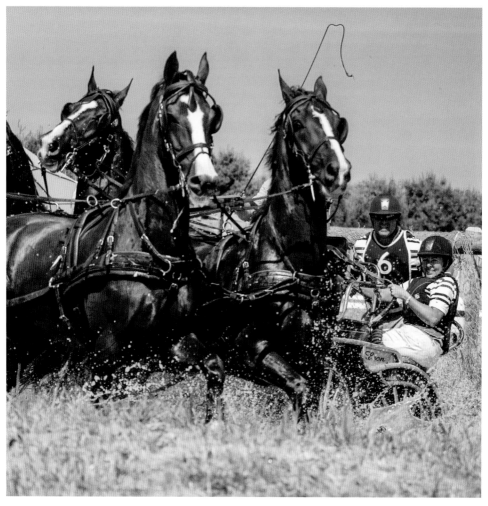

London Grove

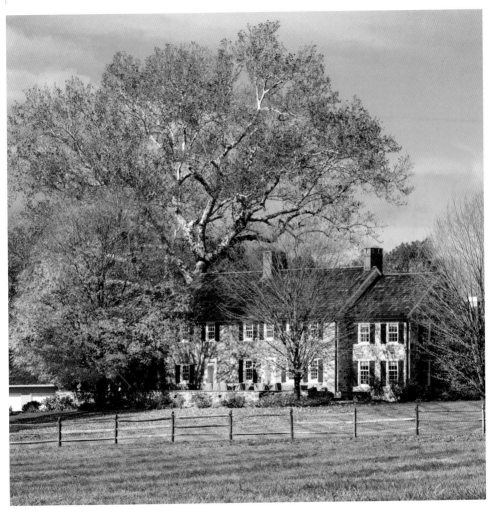

West Marlborough

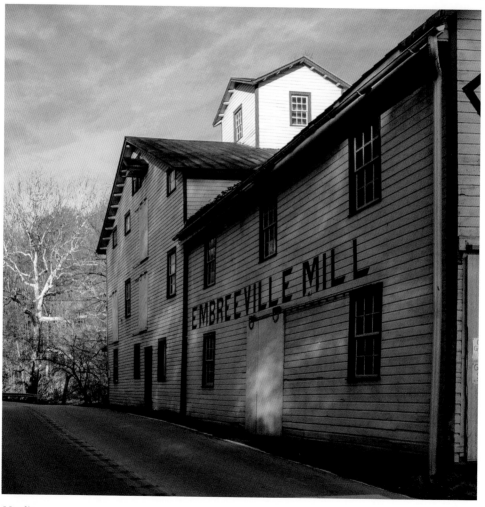

Newlin

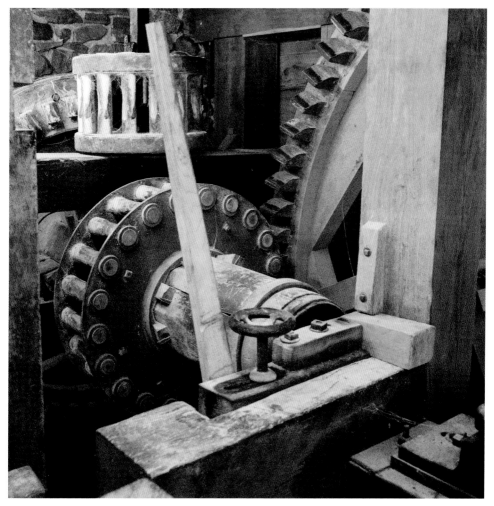

Anselma Mill, West Pikeland

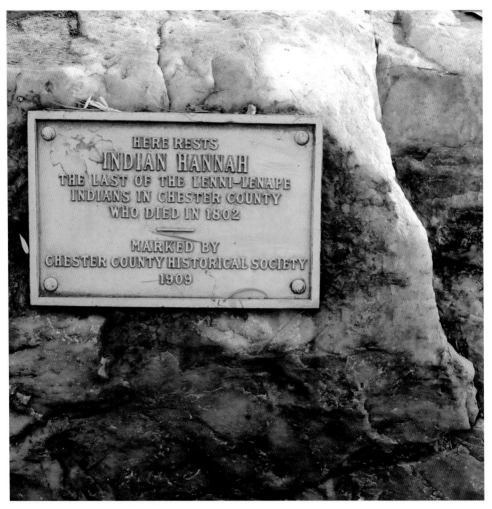

HERE RESTS
INDIAN HANNAH
THE LAST OF THE LENNI-LENAPE
INDIANS IN CHESTER COUNTY
WHO DIED IN 1802

MARKED BY
CHESTER COUNTY HISTORICAL SOCIETY
1909

Kennett

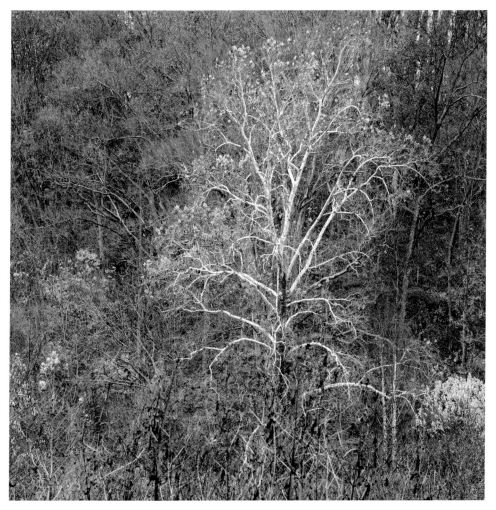

The Laurels, East Fallowfield

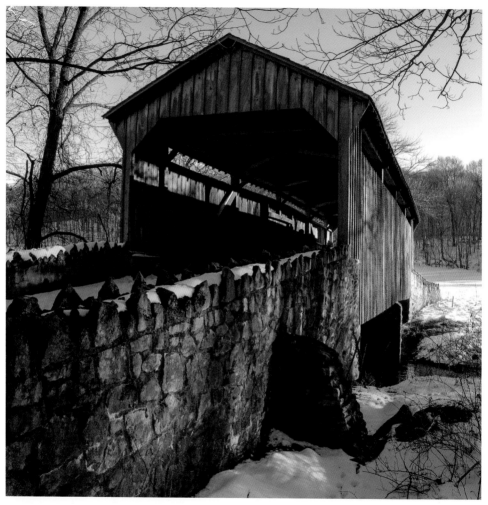

The Laurels, East Fallowfield

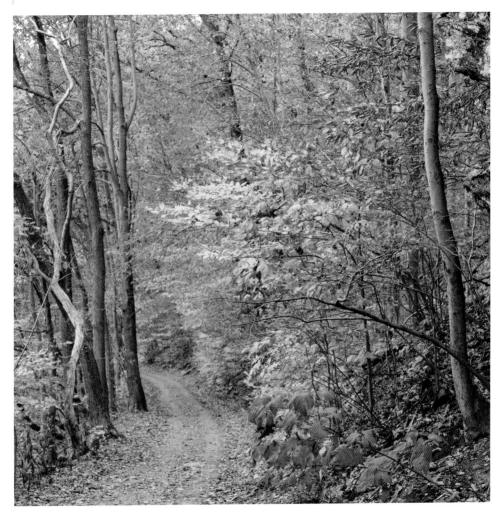

The Laurels, East Fallowfield

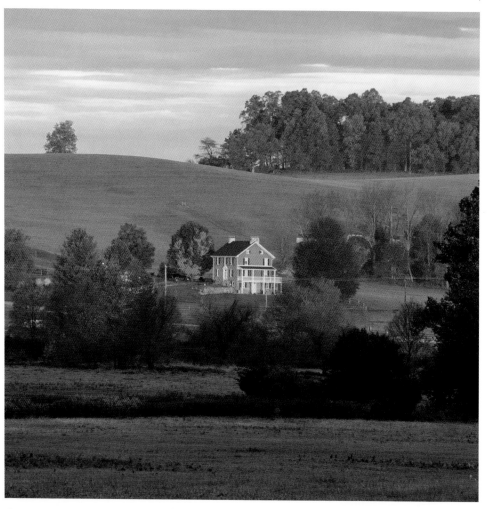

Doe Run, West Marlborough

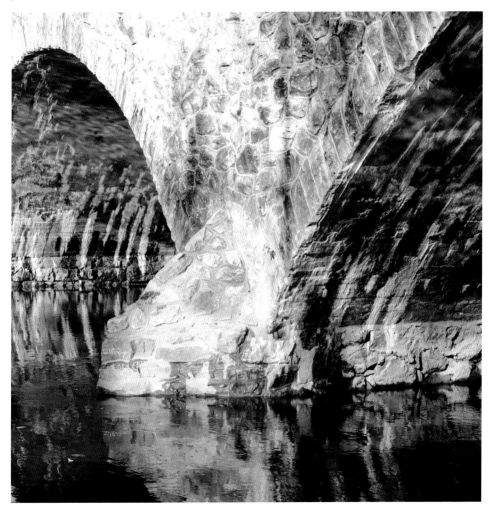

Brandywine Creek, Newlin

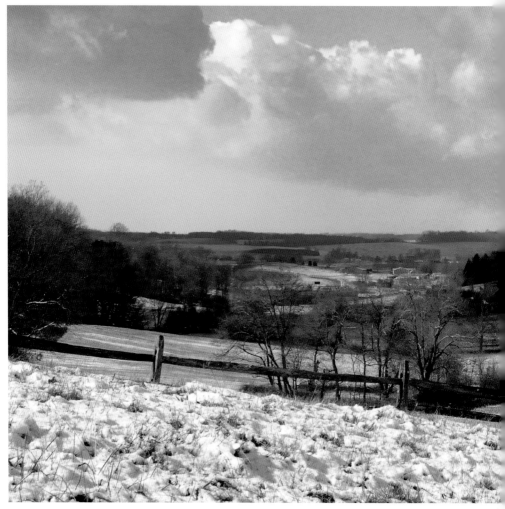

West Marlborough

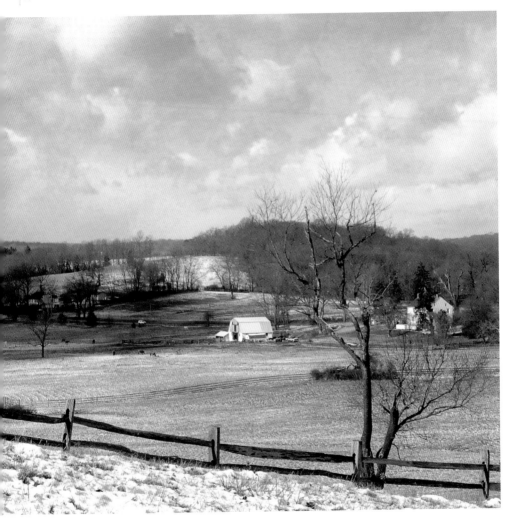

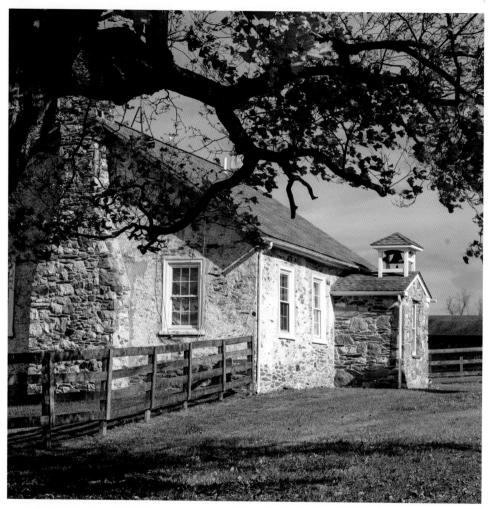

West Marlborough

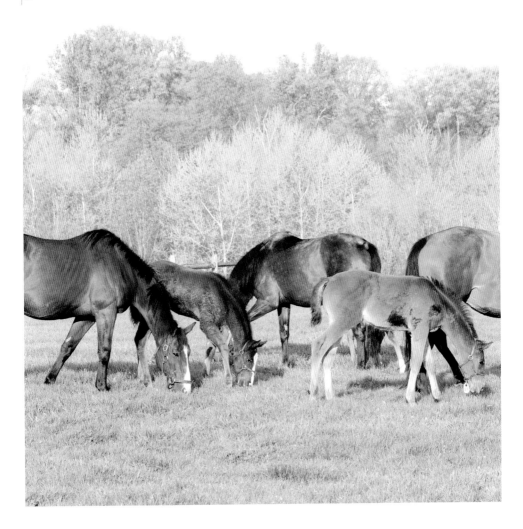

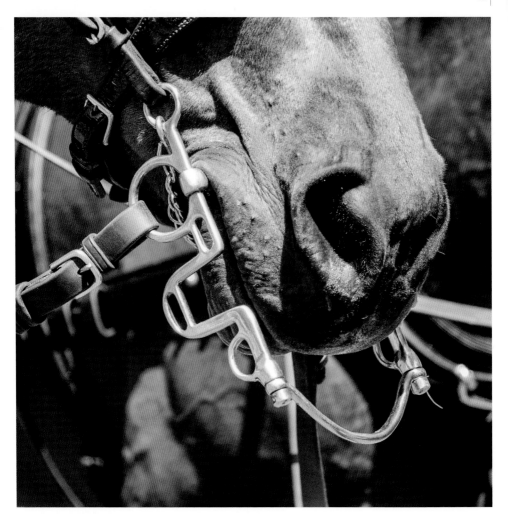

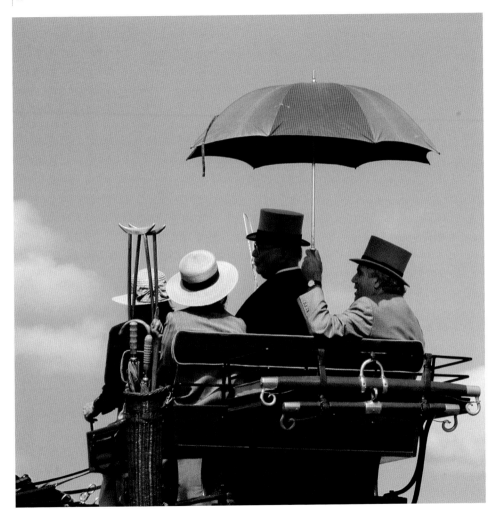

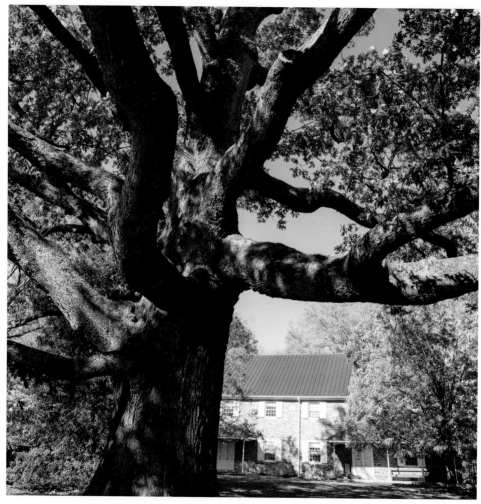

Penn Oak, London Grove Meeting

Stroud Water Reseach Center — "We Grow Trees for Clean Water," Avondale

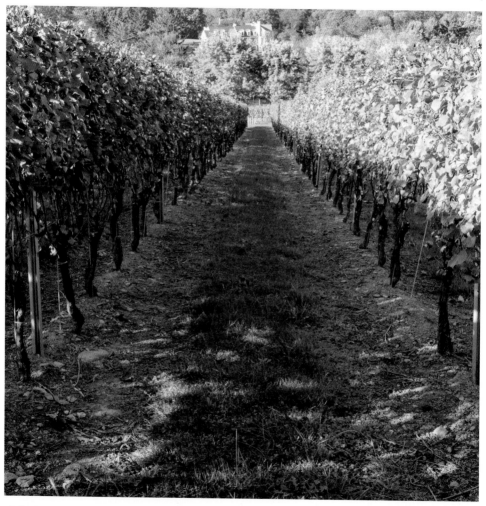

Galer Estate Winery, East Marlborough

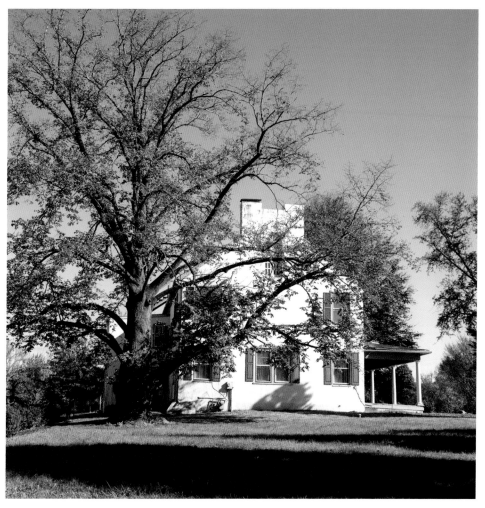

Fusell Farm, Kennett—underground railroad site

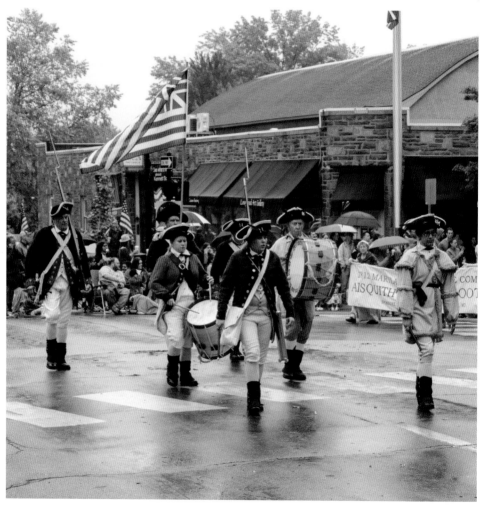

Kennett Square

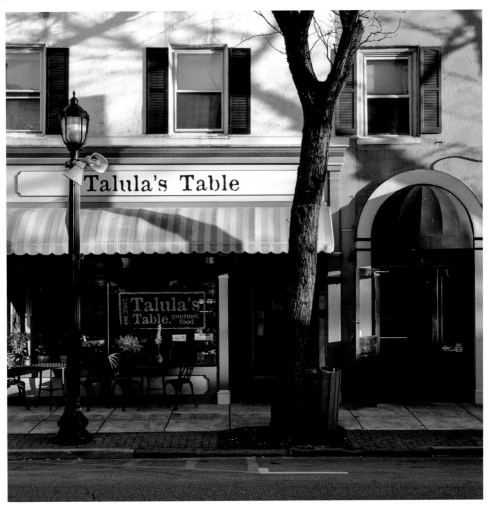

Kennett Square

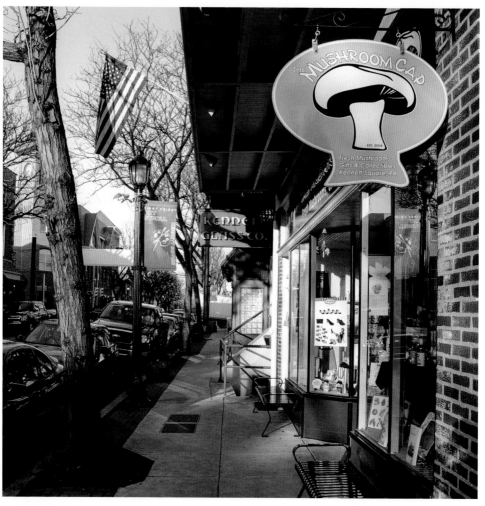

Kennett Square

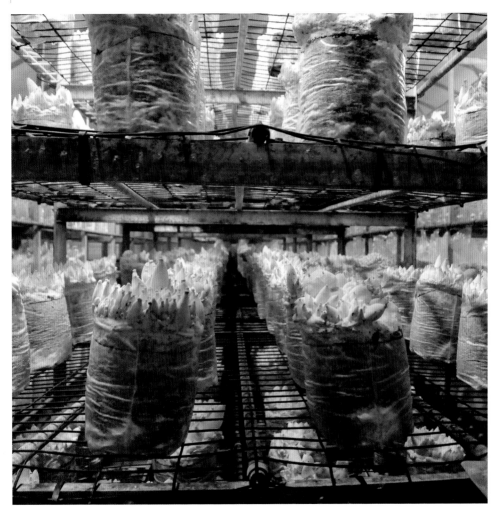

Phillips Mushrooms, Kennett Square

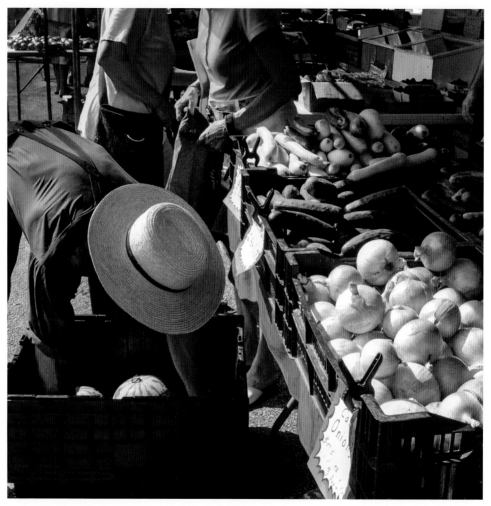

Farmers market, Kennett Square

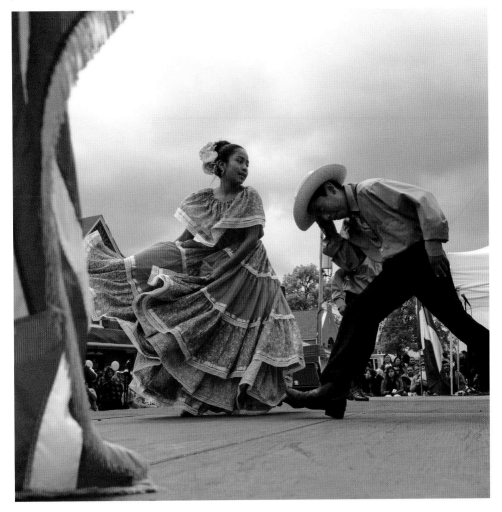

Cinco de Mayo, Kennett Square

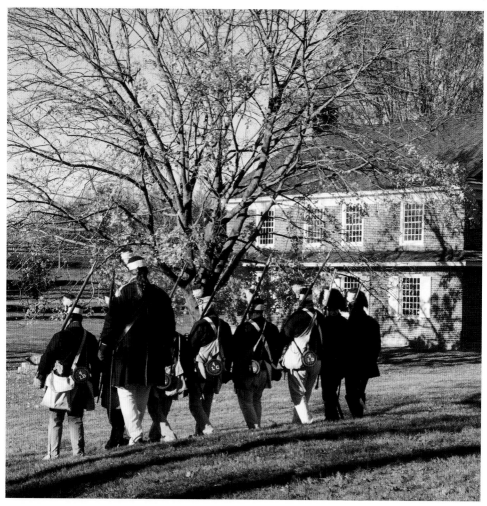

Primitive Hall, West Marlborough

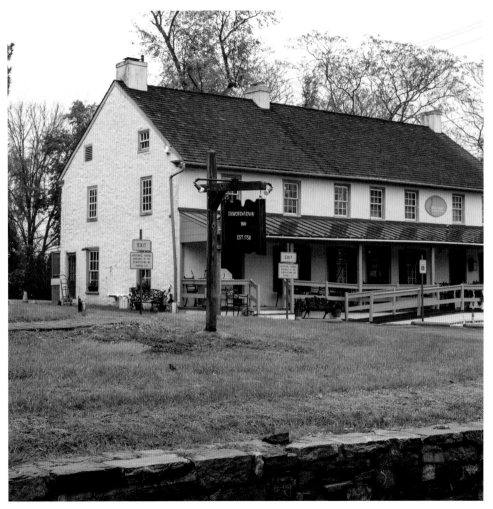

Dilworthtown

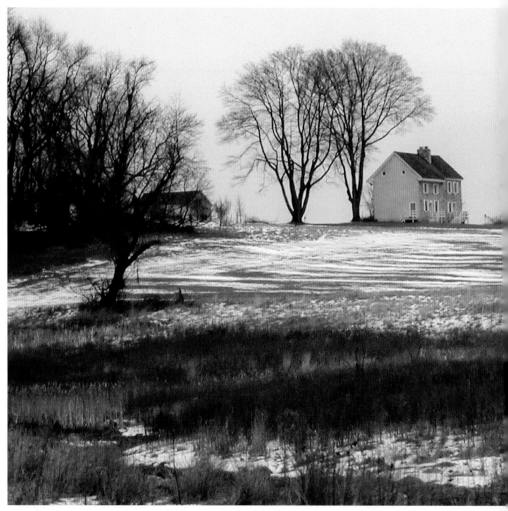

Longwood Gardens

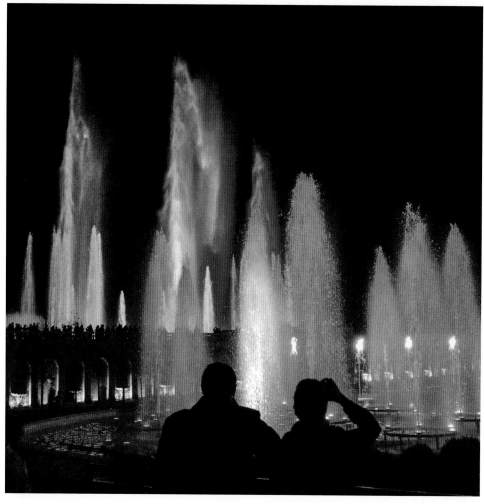

Longwood Gardens

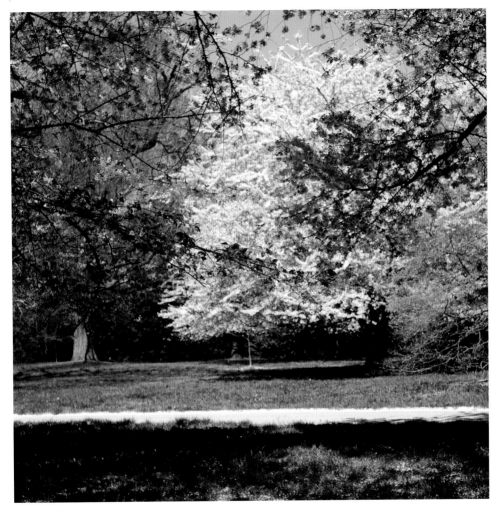

Longwood Gardens

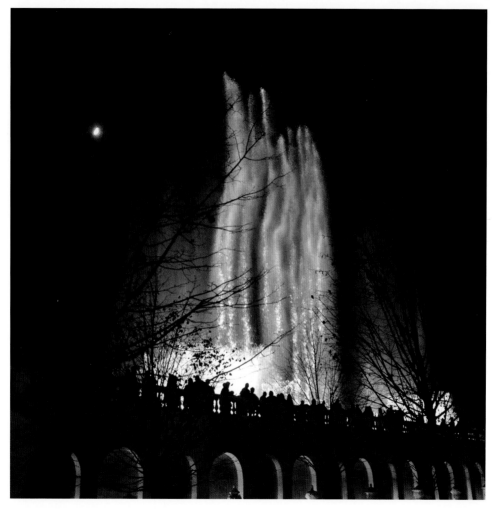

Longwood Gardens

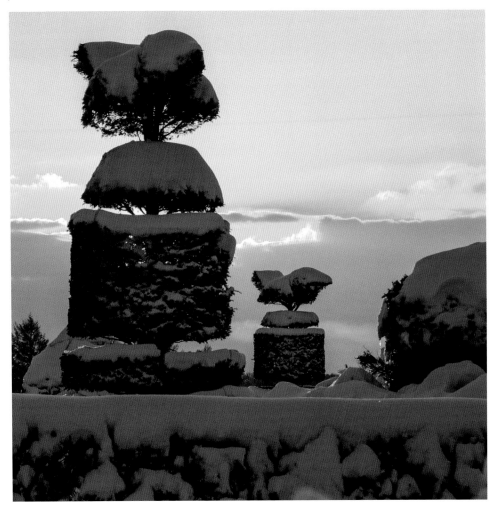

Longwood Gardens

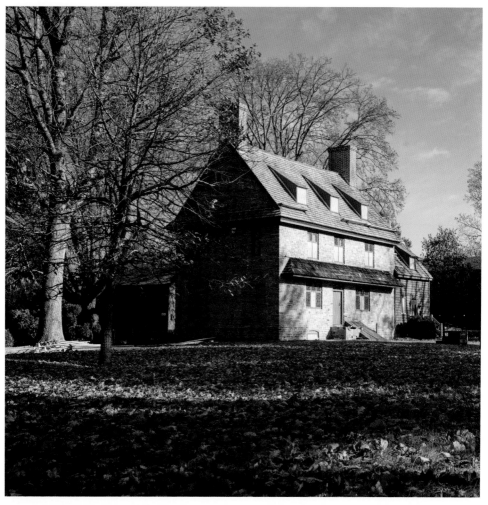

William Brinton House, 1704, Birmingham

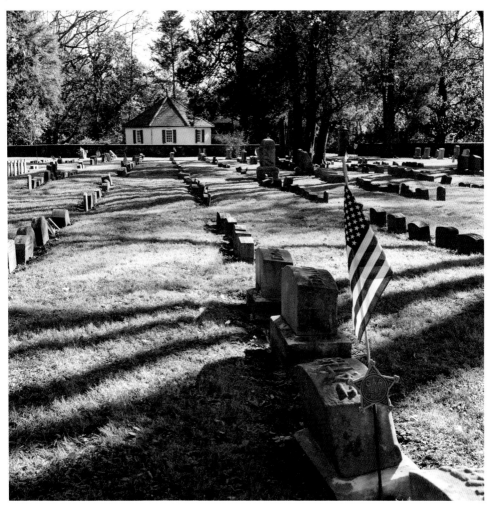

Birmingham Lafayette Cemetery, Birmingham

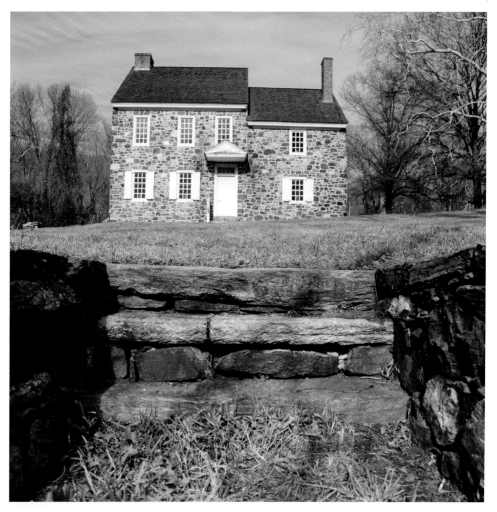

Washington's Headquarters, Chadds Ford

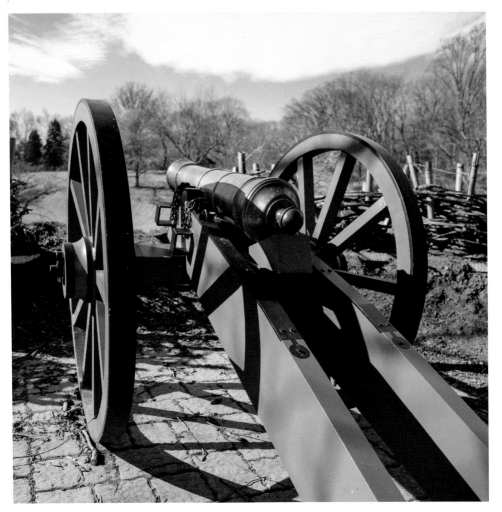

Brandywine Battlefied, Chadds Ford

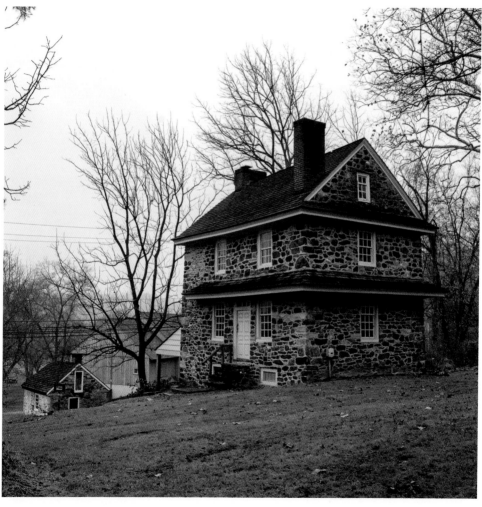

John Chad's House, Chadds Ford

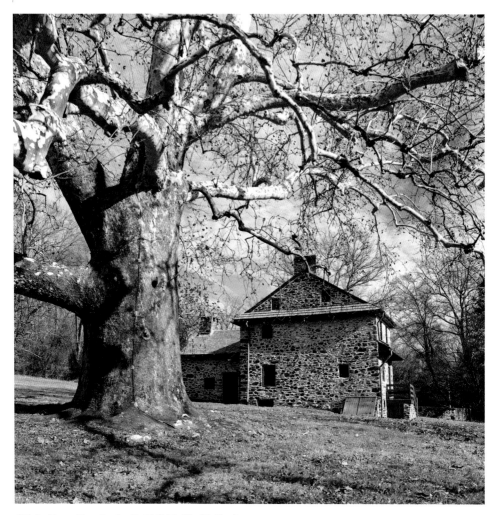

Gilpin Farm, Brandywine Battlefield, Chadds Ford

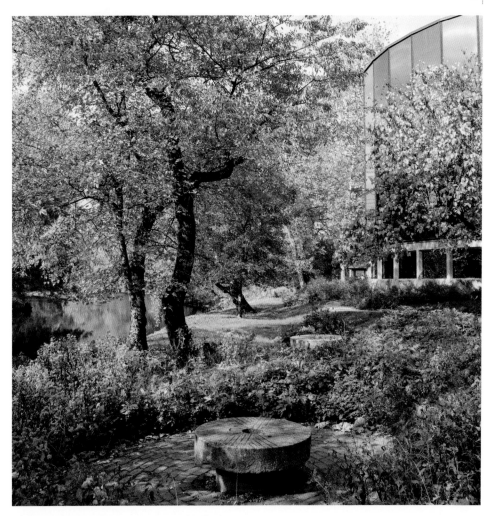

Brandywine River Museum of Art, Chadds Ford

Brandywine River Museum of Art, Chadds Ford

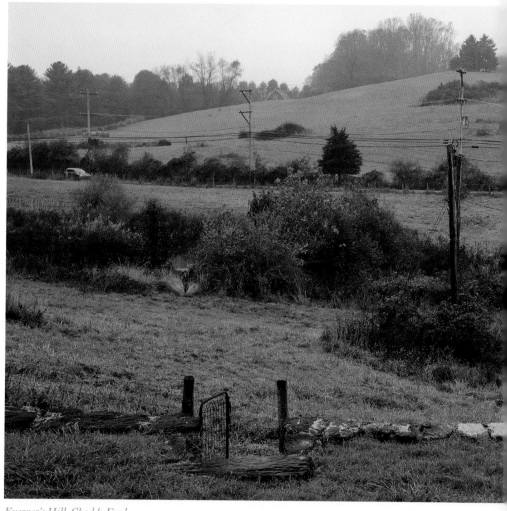

Kuerner's Hill, Chadds Ford

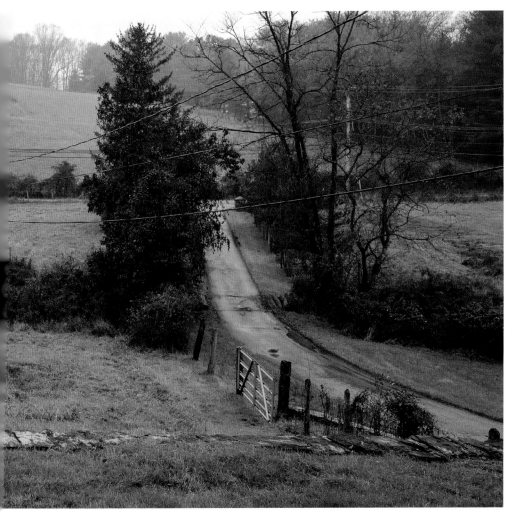

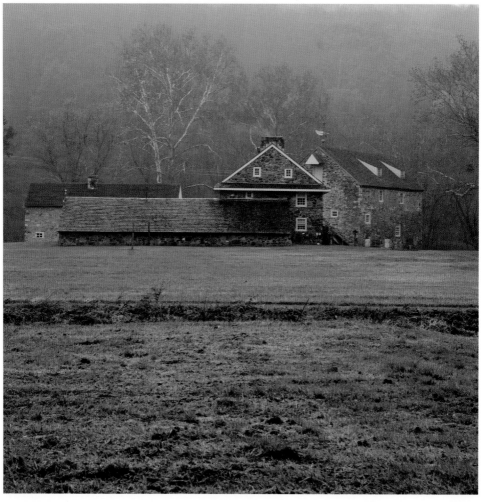

Chadds Ford

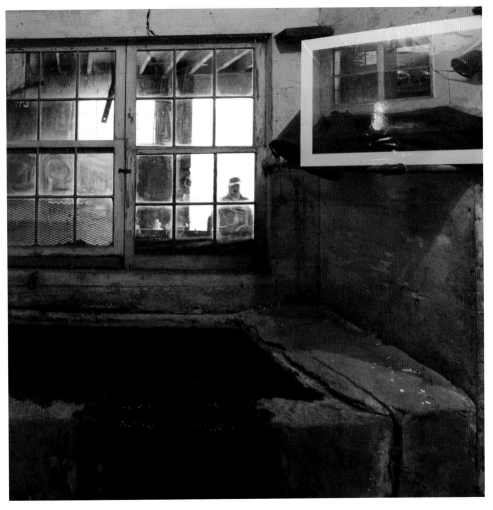

Kuerner's Barn, Chadds Ford

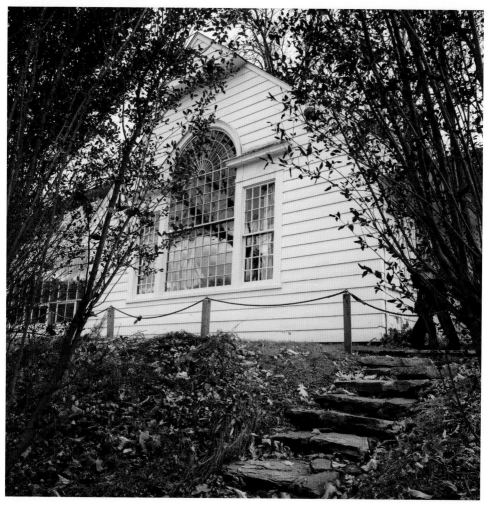

N. C. Wyeth studio, Chadds Ford

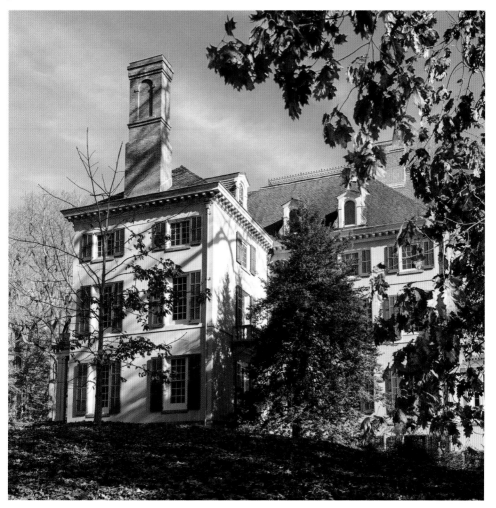

Winterthur House and Museum, Greenville, Delaware

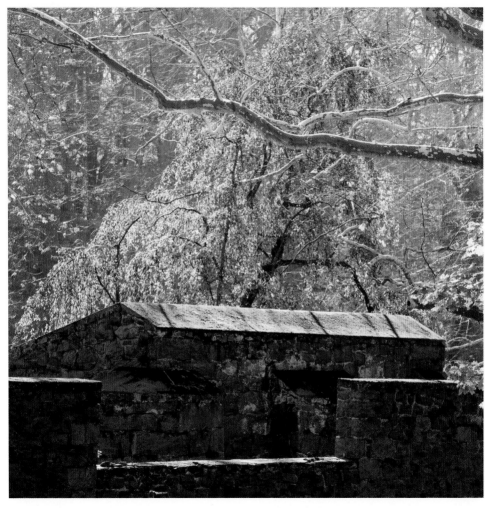

Hagley Museum, Montchanin, Delaware

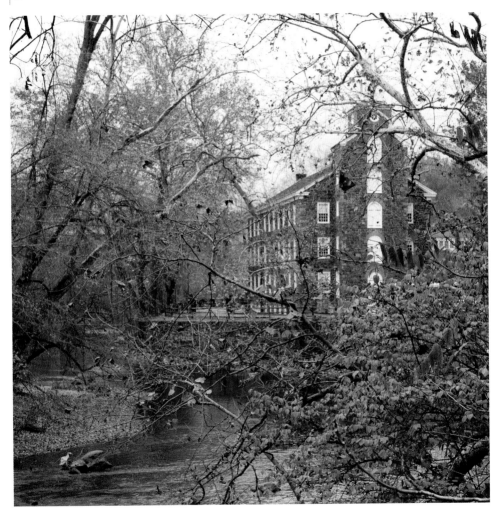

Hagley Museum, Montchanin, Delaware

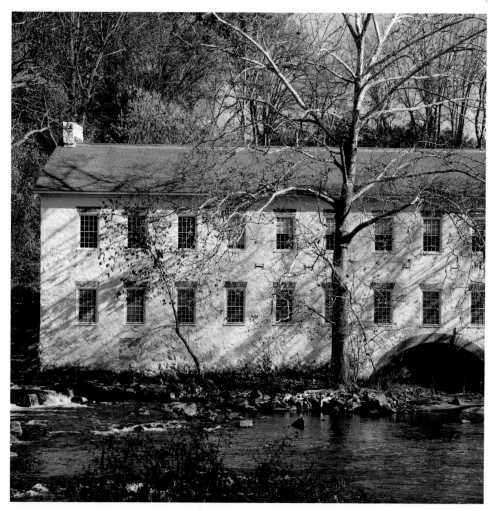

Hagley Museum, Montchanin, Delaware

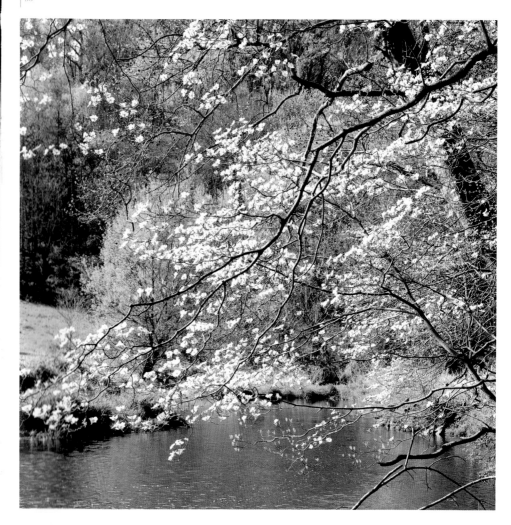

Antelo Devereux Jr. has been photographing for the better part of his life, first as an amateur and more recently as a professional. He has published seven books and has exhibited his images in various venues and galleries in Maine, Vermont, Pennsylvania, and Delaware. He has degrees from Harvard University and the University of Pennsylvania and has studied at Maine Media Workshops. He lives with his family in Pennsylvania and summers in Maine. His photographs can be seen on Instagram.
@photoeye1

Designed by Molly Shields
Type set in Bell MT

ISBN: 978-0-7643-5574-5
Printed in China

Published by Schiffer Publishing, Ltd.
4880 Lower Valley Road
Atglen, PA 19310
Phone: (610) 593-1777; Fax: (610) 593-2002
E-mail: Info@schifferbooks.com
Web: www.schifferbooks.com

For our complete selection of fine books on this and related subjects, please visit our website at www.schifferbooks.com. You may also write for a free catalog.

Schiffer Publishing's titles are available at special discounts for bulk purchases for sales promotions or premiums. Special editions, including personalized covers, corporate imprints, and excerpts, can be created in large quantities for special needs. For more information, contact the publisher.

We are always looking for people to write books on new and related subjects. If you have an idea for a book, pleas contact us at proposals@schifferbooks.com.

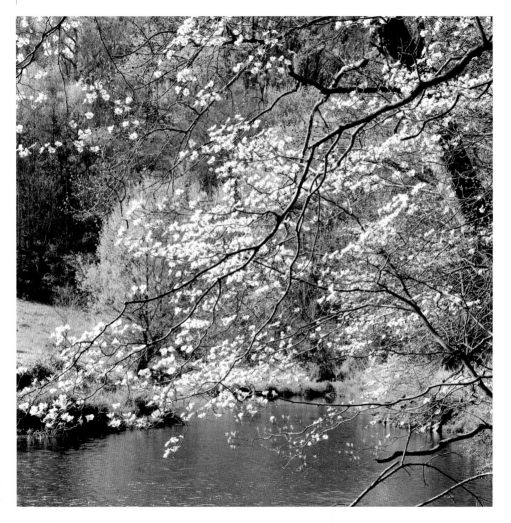

Antelo Devereux Jr. has been photographing for the better part of his life, first as an amateur and more recently as a professional. He has published seven books and has exhibited his images in various venues and galleries in Maine, Vermont, Pennsylvania, and Delaware. He has degrees from Harvard University and the University of Pennsylvania and has studied at Maine Media Workshops. He lives with his family in Pennsylvania and summers in Maine. His photographs can be seen on Instagram.

@photoeye1

Designed by Molly Shields
Type set in Bell MT

ISBN: 978-0-7643-5574-5
Printed in China

Published by Schiffer Publishing, Ltd.
4880 Lower Valley Road
Atglen, PA 19310
Phone: (610) 593-1777; Fax: (610) 593-2002
E-mail: Info@schifferbooks.com
Web: www.schifferbooks.com

For our complete selection of fine books on this and related subjects, please visit our website at www.schifferbooks.com. You may also write for a free catalog.

Schiffer Publishing's titles are available at special discounts for bulk purchases for sales promotions or premiums. Special editions, including personalized covers, corporate imprints, and excerpts, can be created in large quantities for special needs. For more information, contact the publisher.

We are always looking for people to write books on new and related subjects. If you have an idea for a book, please contact us at proposals@schifferbooks.com.